THE BALLAD OF
LOUIS WAGNER
and other New England Stories
in Verse

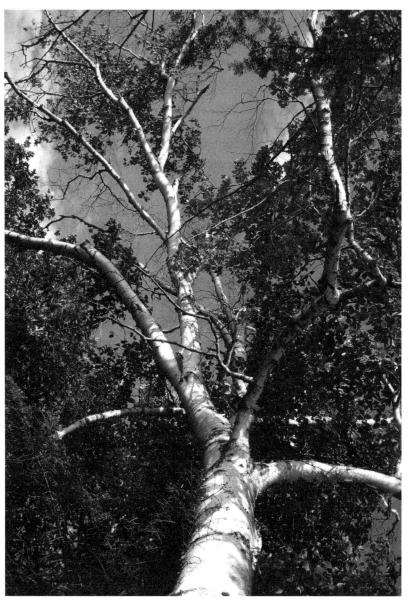

"I went to the woods to confront the facts and raise a little consciousness."

THE BALLAD OF
LOUIS WAGNER
and other New England
Stories in Verse

With a CD of ballads and songs

John Perrault

Photographs by
Peter E. Randall

Peter E. Randall Publisher
Portsmouth, New Hampshire
2003

Text copyright 2003, John Perrault
Photos copyright 2003, Peter E. Randall
Printed in the United States of America

All rights reserved under International and Pan-American Copyright Conventions, Published in the United States by Peter E. Randall, Publisher, Portsmouth, New Hampshire.

Book Design by Peter E. Randall

Peter E. Randall Publisher
Box 4726, Portsmouth, NH 03802
www.perpublisher.com

Frontispiece: Birch, Umbagog

Some of the ballads and songs that appear in this volume were first published, sometimes in slightly different form, on the following recordings by John Perrault: "The Ballad of Louis Wagner," "Chocorua," "Manchester Heartbreak," "Mad River Road," "Some Things Refuse to Fall" on *New Hampshire*; "Sonny's Back" on *Tenants in Common*; "Ballad of the Squalus," "Ballad of Billy Ockham," "Saco River Song," "White-Tailed Deer," "Mouth of the River" on *Country Matters*; "Lucky Jim," "Before You Go" on *Rough Cuts*. The Ballad of Henry D. and the Ballad of Jesse Boorn appear for the first time in print and on the enclosed CD.

Some of the poems in this volume first appeared in the following publications, sometimes in slightly different versions: "Indian Summer Eve" in *Nahant Bay*, reprinted in the *Portsmouth Herald*; "The Stones," "Newfound Lake, Late September" in *Puckerbrush Review*; "The Tugs" in *Soundings East*, reprinted in *Portsmouth Unabridged*; "Three Jays in a Blizzard" in *Snowy Egret*; "Senior Citizen Outing at Winnipesaukee" in *Snake River Reflections*; "Anne Hutchinson" in *The Lyric*.

Library of Congress Control Number: 2003096206
ISBN 1-931807-18-3

John Perrault/Portsmouth Poet Laureate website address:
www.pplp.org

For Holly and Judy

CONTENTS

BALLADS

SONGS

POEMS

PREFACE

Dear Reader, Here are some of the ballads I've written over the years. Till now, they've been scattered on various recordings—some on vinyl, others on cassette, and the latest on CD. With this collection, I'm trying to put a little order in their lives—maybe give them a new lease on life. A few of them have been reworked over time. Some of the recorded versions may differ slightly from the printed ones.

I'm grateful for Holly Perrault's assistance in editing the commentaries to the ballads, for Peter Randall's insights and photographs, for Jeff Landrock's recording skills, and for the musical hearts of Mike Rogers, Ellie May Shufro, Barbara London and Jim MacDougall, all of whom make appearances on the CD. Thanks also to the poets of Skimmilk farm who mowed around a few of the poems.

The Louis Wagner story has been the center of gossip for over a hundred and twenty-five years throughout the Piscataqua region of Maine and New Hampshire. Out on the Isles of Shoals, people camp under Maren's Rock. Everybody has a theory—my ballad is one version of events. It doesn't pretend to historical accuracy in all aspects; however, it generally tracks the murder story without, I hope, doing violence to anyone's character.

Not all the ballads here have specific historical roots. While Louis Wagner, Henry David, the Boorns, Russell Colvin, Gerald McLees, and Chocorua are real figures from the pages of history, Sonny Field, Billy Ockham, Lucky Jim, Paul Dufond's Lover, and Corinna's ex-lover, are human compositions set in historical landscapes. It is because I have had the privilege to know and work with people like Sonny, Billy, Jim, and the two lovers, that I've been moved to imagine their lives, their small joys and quiet sufferings. They are as real to me—and therefore matter—as any historical figure can ever be.

More New England poems, songs, and Peter Randall's photos round out this collection. One of the poems makes mention of Rhode Island. Thus all the New England States save Connecticut are covered. Connecticut will have to wait for volume two.

I've been stumbling over the rocks and roots of Maine and New Hampshire all my life. Stub your toe, twist your ankle, and the ground gets to you. As it clearly gets to Peter Randall's camera. When I first saw Peter's images, I fell right into the pictures. Now, here we are, wandering around in the woods together. It's not that we're lost. Just detained awhile.

–John Perrault

INTRODUCTION

American ballads derive from the English/Scottish tradition. That tradition primarily concerned itself with relating tragic stories of broken-hearted lovers, rape, murder, suicide, hangings, and the occasional return of the ghost. The Renaissance and Age of Enlightenment didn't have much patience with all of this. However, the later eighteenth century saw the beginnings of a revival of these early ballads with the publication of Bishop Percy's *Reliques of Ancient English Poetry* in 1765. Walter Scott and Robert Burns immersed themselves in balladry. Francis James Child of Harvard collected three hundred and five popular ballads from England and Scotland in the nineteenth century. In America, folklorists have turned up over a hundred Child ballads, primarily in the southern mountains and along the Canadian border.

The English Romantic Poets embraced the folk ballad as a fundamental source of the poetic spirit and created a wide body of literary ballads that have stood the test of time—most notably, Coleridge's "Rime of the Ancient Mariner" and Keats' "La Belle Dame Sans Merci." Tennyson and Yeats wrote ballads. So did Longfellow and Auden. Today, of course, we have the master work of Bob Dylan.

The tradition appears to have survived. That shouldn't be surprising. Poetry and music, after all, rise from the same root. The Renaissance split the trunk. The Neo-Classicists went after the branches. But here we are working our grafts, planting new seeds, down by the green wood side-ee-o.

A ballad is a short narrative poem intended to be sung. It is dramatic, intense, and often commences with the characters poised for calamity right in the first stanza. (That stanza, by the way, is generally the standard four-line one, with alternating iambic tetrameter, iambic trimeter lines. The one borrowed by the hymn makers and echoed by Emily Dickinson.) The story continues to be a trag-

ic one. Why? Perhaps for the same reason that we find ourselves, time and again, watching that re-run of *Casablanca* on our video recorders. It is the story of a world where things don't always turn out well. A world in which love marries fate in city hall one afternoon while outside, behind the wheel at the curb, death waits, smoking a cigarette.

In a brief essay called "The Hear-Say Ballad," Robert Frost argues that every ballad calls out for its voice to rise and sing the story. Tune and text must merge if we're to get the full meaning. Frost suggests this is really what all poetry requires—melody and meaning under one tent. I will not argue with Frost. At the back of this book, you will find the voice that goes with the words on these pages.

—JP

BALLADS

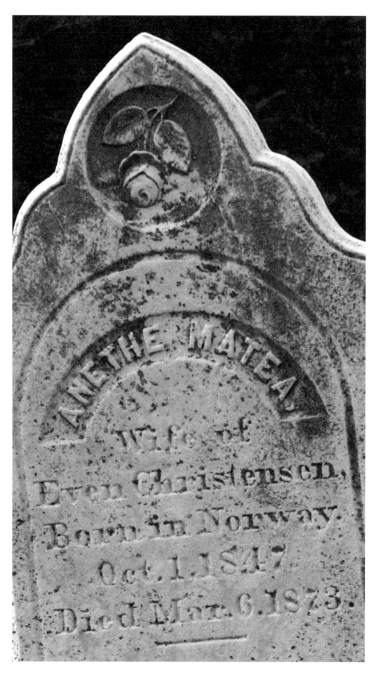

"Anethe, Anethe Christensen, her lovely golden hair—"

BALLAD OF LOUIS WAGNER

In the late sixties I was teaching at Traip Academy in Kittery, Maine. One gray, drizzly afternoon, I was invited out to Rosamond Thaxter's home on Cutts Island for tea and conversation. I was admiring her Childe Hassam paintings of the Isles of Shoals when the talk took a turn to her grandmother, the poet Celia Thaxter. Rosamond then recounted the tale of the murders on Smuttynose in March of 1873. The next day I picked up a copy of Rosamond's *Sandpiper* in which Celia's account is summarized. That led me to other versions of the Louis Wagner story and finally to the trial transcript. Louis was convicted of murdering Karen and Anethe Christensen and sentenced to be hanged. As he stood on the gallows at Thomaston State Prison and waited for the noose to be placed around his neck, Louis was witness to the execution of another convicted murderer, one Gordon True. Gordon had stabbed himself the night before and was barely conscious when dragged to the scaffold. Louis' next to last words were: "Poor Gordon."

Some say Wagner didn't get a fair trial. Suffice it to say, the notion of fairness, in both a legal and social sense, is a dynamic one. It is difficult for us to stand in the shoes and the minds of our forebears. Yet, if we are to have any understanding of what happened, we must try. Perhaps a starting point is to listen to what the witnesses actually said. That requires reading the transcript.

Maren, the lone survivor of the attack, points the finger at Louis Wagner. But she's clear that she heard Karen crying out: "John scared me!" and "John killed me!" as the blows rained down on her. And she's also clear that she never saw the face of the attacker. If she were falsely accusing Louis, would she have quoted

Karen's words? Would she have denied seeing Louis' face? Ask yourself a few questions: Did Louis know the women? Had he stayed in their home? Did he disappear the night of the murders? Was he observed walking from New Castle toward Portsmouth the morning after the murders? Did he shortly thereafter take a train to Boston? Did he buy new clothes and shave his beard? Did he make incriminating statements to third persons? The answers, my friend, are dozing in the transcript.

Art, as they say, is the lie that leads to the truth. None of us can climb inside Louis Wagner's mind. But the imagination can give us a leg up. I have taken certain liberties with the record in order to shine a light beam on Wagner's psyche. Contrary to the historical facts, in the ballad he brings the ax out with him in the dory; he comes up only with a silver chain; he suffers profound guilt after the murders. In my re-creation, Louis is not unlike Dostoevski's Raskolnikov in many ways: a loner—poor, alienated, depressed—someone capable of both human compassion and unspeakable crime: the ax murder of defenseless women. Reading his pre- and post-trial statements, watching the way he handles his last moments, I imagine Louis to have come to the realization, somewhere deep in his subconscious, that his transgression can never fully be forgiven. Like Coleridge's Ancient Mariner, he is doomed to corner the next appointed listener—in Louis' case, someone down by the dock on Ceres St. in Portsmouth during the month of March—and re-tell the whole story. In the purgatory of his soul, he strives to expiate his sin. Temporary relief from the agony of guilt is the best he can hope for.

Ballad of Louis Wagner

The fog peers in the windows, passes 'neath the lamps,
settles in the doorways, huddles from the damp—
slips inside the houses, rooms, the sleeper's bed and dreams;
it rolls him over, turns him out, into the shrouded street.

Dreamer, listen to the river rubbing at the docks,
through the smoky loneliness on Ceres Street we'll walk—
there's someone waiting for us where the tugs are tied,
his name is Louis Wagner and he's waiting there tonight.

Over there by the warehouse, a shadow like a stain,
a man and around his neck, look! A silver chain—
he's pointing at us, fingered us, it's Wagner's laugh all right.
Shh, he's about to speak, God look at his eyes.

"A night like this, just like this, in March and it was cold.
John Hontvet and Ivan Christensen had come in from the
 Shoals—
to sell their catch and buy some bait and pour themselves some
 rounds,
oh those crazy fools had left their wives on the Isles of Shoals
 alone.

"And they wanted me to join them to go out baiting trawls,
but in my mind flashed silver there had been some talk about—
last summer out on Smuttynose when I was Ivan's guest
I heard him whisper to his wife: 'Let's hide the silver in the chest.'

"So I left them in the alehouse pulled by an undertow.
I grabbed my hatchet, shoved the dory out, and I set my back to
 row—
I rowed that dory through the night twelve miles out to sea.
Twelve miles out and twelve miles back it seemed eternity.

"I see the trees on Gerrish Island looming from the shore;
the swell is building under me, I'm digging in the oars—
and a sickle moon comes cutting 'cross my shoulder from the east,
colder than the hatchet blade lying at my feet.

"It's all darkness over Appledore, darkness over Star,
darkness over Smuttynose, pounding in the heart—
and those women out there waiting, Anethe, Anethe and Marie—
and Karen, Ivan's sister, she was so good to me.

"Lunging Island to my left, Malaga to my right,
Smuttynose lies dead ahead I can just make out the light—
and the rhythm of my rowing, it's coming faster now,
the halfway rocks just off the stern and death just off the bow!"

Refrain:

Louis, Louis Wagner, rowing through the night,
Louis, Louis Wagner, the noose will fit you tight—
silver chain around your neck, silver in your eyes,
silver in your Judas soul that never never dies.

<center>~</center>

"The wind now whipping from the west and the swell will not be
 tamed,
the ocean building to a roar and the mind will not be changed—
this boat will have its landing, this sea will have its flood,
these hands will have their silver and the devil will have his
 blood.

"One lamp in the window, a beacon 'cross the ice,
safe harbor for the weary, safe keeping for the night—
comfort for the sailor wrecked upon the sea,
terror for those gentle folk who once befriended me.

"I'm gliding into Haley's Cove and there's not a soul in sight,
I grab my hatchet and I climb the bluff headed for the light—
the snow is sucking at my boots, the ice gnawing at my hands,
but the blood is boiling in my veins—the blood—do you under-
 stand?

"I smash into the cottage, my hatchet swinging wild!
Anethe leaps up from sleeping, her eyes are like a child's—
she screams 'God, John, God!' running from the room,
I grab her in the doorway, the axe glints in the moon!

"Fire racing through my brain, explosions in my eyes!
Anethe lying on the floor and Karen screaming: 'why?'
The axe, the blood, the sky, the moon, the pounding of the sea—
the howling of the crazy wind, the wind—or was it me?"

Refrain:

Louis, Louis Wagner, raging in the night,
Louis, Louis Wagner, the noose will fit you tight—
silver chain around your neck, silver in your eyes,
silver in your Judas soul that never never dies.

 ~

"Anethe, Anethe Christensen, her lovely golden hair
all smeared with blood, all splashed with blood, oh God it was
 everywhere—
and Karen, gentle Karen—she just wanted to be my friend,
she made me well when I was ill, her blood is on these hands!

John Perrault 5

"Marie? Marie she got away, she ran barefoot through the snow.
I followed her tracks through the craggy rocks but the moon was
 falling low—
I couldn't find her anywhere and I went back for what I came,
but in the chest I only found this piece of a silver chain.

"Oh this icy piece of a silver chain and there was nothing more.
I threw the chest against the wall and I smashed the bedroom
 door—
I ripped apart the still-warm beds, I tore up every shelf;
I cursed the very universe and then I cursed myself!

"I stumbled down to the dory and I flung the hatchet in,
I shoved off for the mainland fighting time and wind—
the dawn was breaking bloody red when I rowed into Rye—
I threw myself down on the beach and I hung my head and cried.

"I made it to the train to Boston but nothing was the same,
and every woman on that coach kept whispering their names—
'Anethe,' 'Anethe' and 'Karen,' they were with me all the while.
Then they took me back to Kittery and I had to stand for trial.

"Well the judge was steaming on the bench and the jury num-
 bered twelve,
and a thousand eyes inside that room condemned my soul to
 hell—
I was seated in the dock, Marie was on the stand,
and right behind me, I couldn't look, were the eyes of John and
 Ivan!

"The judge looked toward the doorway and the jury disappeared,
and a hush rolled through that courtroom like a fog across a
 pier—
then the judge he banged his gavel and the jury took their seats,
and the foreman stood and he pointed at me and he said: 'Guilty
 in the first degree!'

"Oh the sun had not yet risen, there was a moon still in the sky,
they took me from the prison with the sleep still in my eyes —
and the moonlight on the gallows made that noose like a silver
 chain!
And as I fell I heard Karen pleading: 'Louis, won't you be my
 friend?' "

Refrain:

Louis, Louis Wagner, hanging in the night!
Louis, Louis Wagner, the noose now fits you tight —
silver chain around your neck, silver in your eyes,
silver in your Judas soul that never never dies.

 ~

Well Karen's question gets no answer for the wind's beginning to
 rise,
and the fog's rolling out with the river, look at the run of the tide —
and now a moon, a sickle moon, is rising just offshore —
and out beyond the tugboats, listen, you can hear the dip of his
 oars!

Dreamer — in March at Portsmouth Harbor when the night puts
 on her mask,
and the fog prowls the dripping street you might hear a stranger
 laugh —
you might feel a bloody finger jabbing your moral soul —
for Louis Wagner is bound to relive what happened on the Isles
 of Shoals.

" I'll take you in my birch canoe, we'll paddle all the way to Mars…"

BALLAD OF HENRY D.

I've been a Thoreau groupie since high school. When our twin daughters were six or seven, Holly and I took them out to Walden to wet them down with a little history. They ran around the area where his cabin once stood and wanted to know why we drove all that way to look at trees and a pond. It was too cold to swim. Damp in the woods. Why would he want to live out there? Didn't make much sense. In 1845 it didn't make much sense to the folks around Concord either.

Thoreau has been a thorn in the side of authority for over one hundred and fifty years. That's why high school students love him. It's not that he's disrespectful. He just calls it as he sees it—people living lives of quiet desperation; government run amok. Like a proud adolescent he'd rather go to jail than cave. (I've included that bit of apocrypha about Emerson coming to the cell window to make inquiries as to the extent of Henry's misbehavior.) At first read, he looks like an easy target for the anarchists to co-opt, but he cares too much for humanity to allow them to get away with it. There's no one party or ism out there that can print Henry on their T-shirts and expect to wear him very long. But one thing is clear: Henry's voice resonates through the forests, across the deserts, and on the waters of the world even as we speak. Mahatma Ghandi and Martin Luther King are but two moral giants who picked up its vibrations and reechoed that voice to people everywhere thirsting for justice. Consider where we'd be today if, instead of going to the woods to confront the facts, Henry had decided to make it with pencils—become the CEO of the family business, build a big spread out at the Pond properly posted: PRIVATE PROPERTY. Perhaps Henry had a little too much of Billy Ockham in him to make the grade.

9

Ballad of Henry D.

"Henry D." they call me when it's time to go to church
on the only day that they don't say that it's time to go to work,
but work for them means pencils, and pencils—I just can't—
my kind of work is out in nature's manufacturing plant.

My father was a shopkeep before the pencils won,
in July of 1817 I became my father's son;
I grew up exploring Concord, I've got Concord in my blood—
canoed and swam the river by the rude arch that spans the flood.

Refrain:

David Henry, Henry D, so good to see you back—
it's been so long since Walden Pond, since living in a one-room
 shack.
Let's get you out those hiking shoes, Cape Cod and Maine—how's
 that?
A birch canoe and a book or two for the Concord and the
 Merrimack.
For the Concord and the Merrimack.

~

I went out to Walden Woods to live life to the bone,
suck the marrow out of it, deliberately, alone;
I see men in desperation, I see ladies in distress—
I went to the woods to confront the facts and raise a little con-
 sciousness.

Consciousness—that's a funny word—it was beans I raised in
 fact;
watching them poke up through the dirt, well that's quite a con-
 scious act—
simplicity! simplicity! what more do you really want?
Just enough to eat and a good night's sleep and a roof for the bats
 to haunt.

I spent most nights just listening to the hounds and how they'd
 howl,
to the little creatures scuttling, to the wing beats of the owl;
listening and looking out and waking up my eyes
to the sleep of all my countryman, just snoring away their lives.

Refrain: Henry David, Henry D…

 ~

Oh I know they say I'm ornery, I'm not one much for fun;
I don't drink but I can dance and I know how to handle a gun—
I'd like to think that trying to think can make a satisfying life,
and I can love, won't say who, even if I don't have a wife.

I strolled to town one afternoon and I found myself in jail,
hadn't paid my polling tax, (I'm a white Anglo-Saxon male);
Ralph Waldo at the window, he says: "Henry— you in there?"
I strained my eyes, it was quite a surprise, I said: "Ralph, what
 you doing out there?"

I was born into this democracy, a majority of one;
I hope to make my way in life without stepping on anyone—
You stand for abolition? You're against this Mexican War?
Then you've got no choice, you've got to raise your voice, what
 else is conscience for?

Refrain: Henry David, Henry D…

 ~

John Perrault 11

I tune my flute to the western wind, to the universal key;
the music of the spheres they say makes quite the harmony—
I'll take you in my birch canoe, we'll paddle all the way to Mars,
drag our feet in the gravel bed of those grainy, mystical stars.

"Henry D." (they're calling me), "it's time to go to bed."
"It's time to put that pen back down, pull the covers up over your
 head."
But covers for them mean sheets to sleep, and white sheets—I just
 can't—
my kind of cover is colored green in nature's manufacturing plant.

Refrain:

David Henry, Henry D, so good to see you back;
it's been so long since Walden Pond, since living in a one-room
 shack.
Let's get you out those hiking shoes, Cape Cod and Maine—how's
 that?
a birch canoe and a book or two for the Concord and the
 Merrimack.
For the Concord and the Merrimack.

~

Sonny's Back

How many Sonny Fields are there out there? Boys who went away to a far away war—shot up and shattered and never quite able to get back home. What they've seen, what they've suffered, no song can ever really tell. But we must know there's more than shrapnel moving around inside those wounds their hearts continue to bear.

Unlike the feted soldiers coming home from WWII and Korea, the Vietnam Vets were largely ignored, if not disparaged. The tide had turned against the war at home. We lost. Not much to celebrate there. Aside from the officers, they were mostly working-class boys. Didn't have the connections, degrees, jobs, that kept most of us savvy middle-class fellows on the deferment lists. Over the years they've come to see their government cut back on services they are in dire need of—to hear the political leaders who sent them into the jungles tell us all the whole thing was a big mistake. Now they tell us.

Let this Sonny Field step forward, then, and give us a glimpse of what coming back can be like for a vet. Maybe, if we look long enough, we might see a few scars no foreign enemy ever inflicted. See a few eyes haunted by a history engraved in stone—just down the road from the Lincoln Memorial.

"…he watched the flashing foam and he lay there silent…"

Sonny's Back

When Sonny Field came home from the army,
the night put her finest silkens on;
she met him at the station outside Bradley
and she walked him 'cross the river back to Old Town —
a tired old grizzled husky grumbled lazy
and Lucina's kids came running down the path;
they kicked the dust around and talked like crazy,
and Jigger yelled "Hey Ma, Sonny's back."

Now Lucina carried forty years like twenty,
her braid still shiny black, high-boned and long;
since high school it was on and off with Sonny,
through the bottle and the three tours in Vietnam —
she banged that screen door wide and she came running,
Sonny dropped his satchel in the grass;
Lucina was on top of him and crying:
"Sonny, Jesus Sonny, you've come back!"

Little Jesse pulled a knife from Sonny's satchel,
Jakata clung on to Lucina's hand,
Sonny said "Little Jessie, now you be careful,"
then to Jigger "You look just like your old man…."
Well, Jigger he turned away and he started walking,
Lucina said "Come on Sonny, don't mind that —
there's coffee on the stove and we need talking,
you know, this time we never thought we'd see you back."

Refrain:

Sonny's back.
Sonny's back and that's a fact you can't retract….Sonny's back.

~

Well the moon eased out on the branches of the oak limbs,
edged up on the window like a tom;
peeked in on those two kids sleeping tightly,
checked out Jigger's empty bed and room —
saw Sonny spread the silk he bought in Saigon,
saying "Lucina, have you changed? I've got to ask."
And Lucina saying "Sonny, it's been so long.
Oh it's beautiful, I wished I knew you was coming back."

Out in the cataract the salmon fought the current,
Jigger up on the rocks down by the falls;
he watched the flashing foam and he lay there silent,
in the silver night, he looked so very small —
the thicket snapped and his heart leapt on the boulder,
Sonny was beside him like a cat;
he put his thick arm round his boy's thin shoulders,
and he said "Jigger, ain't you glad to see me back?"

"Ma's been seeing Benny Woods on week-ends,
he bought me and Jesse each a twenty-two;
Jakata sits up on his lap, she likes him,
Christmas time, we never heard from you —
the Penobscot's running salmon just like you promised,
I've been waiting on you and them this year and last;
tonight you both show up, it's kind of senseless,
Benny said he'd go away if you came back."

Refrain:

Sonny's back.
Sonny's back and that's a fact you can't retract….Sonny's back.

~

Now the night slipped like a brave beyond the river,
and the cabin blushed a little in the dawn;
Lucina pulled the covers up and shivered,
her coffee face cradled in her arms—
Sonny's watch ticked time upon the bureau,
beside his silver tags and photograph;
she felt a heavy hand upon her pillow,
and she heard Ben say "I see that Sonny's back."

Jigger slams the door and now he's crying.
Ben grabs his gun and he walks outside.
Sonny's by the diesel Ben's been driving,
and he says to Ben "I'll bet she rides real fine."
Jigger runs back out with Sonny's satchel,
Lucina's in the doorway with her past;
Ben stands like a soldier with his rifle,
and he says "Sonny, you turn around now and don't you come
 back."

Jigger runs to Sonny and he hugs him.
Sonny says "Jigger, be brave son,
you're going to be a strapping buck and handsome—
stay off the booze, stay out of Vietnam."
Lucina walks toward Sonny just like she's going to touch him,
with her eyes she says 'you know I never felt so bad…'
Then she and Ben and Jigger and the little ones,
watch the sun flicker through the trees on Sonny's back.

Refrain:

Sonny's back.
Sonny's back and that's a fact you can't retract….Sonny's back.
Sonny's back.

 ~

"…we had a cup of coffee, his last name was McLees…"

BALLAD OF THE *SQUALUS*

On a rainy morning in the spring of 1995, I had coffee with Gerald McLees in a Portsmouth cafe. I had been reading about the sinking of the submarine *Squalus*, and a friend pointed me in the direction of "Mac" McLees who survived that 1939 tragedy. "Mac," a warm, energetic, blue-eyed man of eighty years, told me the story in a straight forward, matter-of-fact way. No exaggerations, no dramatics.

The *Squalus* (the name derives from the small shark) was a brand new Portsmouth-built diesel sub making her nineteenth dive in rough seas outside the Isles of Shoals. There were fifty-nine men on board, including three civilians, for this test dive. Moments after nosing down at sixteen knots, tragedy struck. Despite the control board lighting green for safe dive, the main engine induction valve failed to close and the ocean roared into the engine rooms. Ollie Naquin, commander of the ship, ordered ballast tanks blown, but so much water had been sucked in that the *Squalus* tilted back and slowly sank to the bottom in two hundred and forty feet of water. Following standard emergency procedure, Naquin ordered the bulkhead doors to be "dogged down" to protect the command center of the ship. Just before the bulkhead was slammed shut, seven sailors from the rear compartments managed to scramble through to safety. That left twenty-six men trapped on the other side. All were lost.

The *Squalus*' sister ship, the submarine *Sculpin*, retrieved the *Squalus*' marker buoy approximately four and a half hours after the sinking. The buoy contained a phone to allow the rescue ship communication with the sub; however, rough seas severed the line and

the *Sculpin* lost the location of the *Squalus*. Expert divers were flown in from Washington, a rescue ship, the *Falcon*, with a diving bell on board was dispatched from Groton, Connecticut, and the remaining thirty-three men were saved after thirty-nine hours in the pitch-black sub. It was the first time in naval history that a diving bell—this one known as the McCann Rescue Chamber—was ever used in an actual rescue. Only seven men went up on the first run, which took two hours. Nine men each on the second and third runs. The last run with eight men got snagged half way up and hung suspended for four hours before being hand-hauled to the deck of the *Falcon*. "Mac" told me "we knew they'd come and get us."

On September 15, 1939, the *Squalus* was towed back into the Portsmouth Yard where twenty-five bodies were retrieved from the sub. One body had apparently floated out an open hatch.

"Mac" grew up in Kansas. By graduation from high school, the biggest bodies of water he'd ever seen were farm ponds and the huge puddles left after summer rains. The first thing he did was hitch to Topeka, visit the Navy recruiting office, and sign up. After boot camp in San Diego he was stationed to Pearl Harbor. Pearl Harbor of 1938, "before anyone ever heard of it." There he volunteered for submarine duty. The *Squalus* was re-christened the *Sailfish* and sent to the Pacific where it sank seven enemy ships during the course of the war.

"Mac" was one of only three survivors who volunteered to go back to sea on the *Sailfish*. Why? "It was either that or be transferred back to California. My sweetheart lived in Portsmouth."

Ballad of the *Squalus*

I ran into an old-time sailor up on Market Street,
we had a cup of coffee, his last name was McLees;
he fought in the Pacific on Portsmouth submarines,
I asked about the *Squalus* — this is what he told me:

"*Squalus* was a diesel sub built at Portsmouth Yard,
gearing up for WWII our crew was pressing hard;

running her through sea trials, May 23rd, 1939 —
in a whipping wind we went out again with fifty-nine men inside."

Refrain:

Yes, my friend, fifty-nine men, only thirty-three survived —
how many thousands broke their backs just to make this ship a
 prize?
Oh, I could tell you of the *Stickleback*, and how the *Thresher* died —
two hundred years we built the boats, Portsmouth paid the price.
Ah, the Portsmouth Yard; it was down at Portsmouth Yard.

~

"Just outside the Isles of Shoals, Ollie Naquin in command,
I see him now up on the bridge, 'Stand by to dive all hands;'
bow planes swing out from the hull, klaxons wail and whine,
tanks for ballast open up and the *Squalus* makes her dive.

"Battery engines take us down, intake valves are closed,
the board lights green, it means everything is steady as she goes;
now this jolt! and a yeoman jumps, it happens all on a sudden;
he rips his earphones off and cries: 'The engine room is flooding!'

John Perrault 21

" 'Blow the ballast! Blow the tanks! Blow the bow and turn her!'
Well, the bow comes up just a little way, but there's too much
 weight a-sternship;
she tips back on an angle tilting ten degrees to forty —
She's going down, slipping down, shorting out the batteries.

" 'Dog down the doors!' Naquin shouts, and a seaman grabs the
 bulkhead —
'For God's sake wait!' a sailor cries, and seven men scramble for-
 ward;
there's water up around our knees, before the bulkhead closes,
twenty-six men on the other side, I can still hear their voices."

Refrain: Yes, my friend...

 ~

"Silence at the bottom of two hundred and forty feet of water,
darkness cold and icy calm, Ollie Naquin gives this order:
'Men still yourselves, try to rest, we've got to save the oxygen;
we'll float a marker up to spot us, but for now the wait begins.

" 'Listen...I hear something, like a rumble in a fog —
men take hammers and bang the hull, bang like hell by God;
oh they're up there looking for us, I know it in my bones,
those guys would risk their lives to get us out and bring us home.'

"Searches grab the orange buoy, now they're dragging grapnel,
a diver's boots land on the hatch, they're lowering down the life
 bell;
thirty-three men brought up alive, after thirty-nine hours of
 dying,
four months later, twenty-five men towed in for identifying.

"September 15, 1939, people lined up at the gates,
waiting for those shiny hearses carrying their mates;
wives and lovers, sons and daughters, standing in the Kittery rain,
they've stood out here like this before, and they'll be standing out
 here again."

Refrain: Yes, my friend…

<div align="center">~</div>

McLees, he sipped his coffee, stared out at the rain,
"I don't get out so much today," he said, "you know this town has
 really changed;
I guess I just lost track of time, it's about that time to go—
why twenty-six men and not fifty-nine? Well that I'll never know.

"The *Squalus* sat in dry dock, rebuilt and re-commissioned,
the engine room they called 'the tomb,' well that's all superstition;
they re-christened her the *Sailfish*, but she's the *Squalus* in my
 dreams—
every night I go back down inside that submarine."

Refrain:

Yes, my friend, fifty-nine men, only thirty-three survived—
how many thousands broke their backs just to make this ship a
 prize?
Oh, I could tell you of the *Stickleback*, and how the *Thresher* died—
two hundred years we built the boats, Portsmouth paid the price.
Ah, the Portsmouth Yard; it was down at Portsmouth yard.
Ah, the Portsmouth Yard; it was down at Portsmouth yard.

<div align="center">~</div>

<div align="right">*John Perrault* 23</div>

"… there goes Billy down the wrong track and he ain't coming back no more."

BALLAD OF BILLY OCKHAM

Today Billy Ockham would probably be on Ritalin. Squirmer, teaser, trouble-maker, misfit, outcast—what can he ever hope for himself—for his future? Notice, no father in the picture. Notice, too, no excuses. Not from Billy. And certainly none from any of the representatives of American civilization circa 1985 who are trying to wrestle Billy to the mat. Yet these accomplished professionals—teachers, principals, headmasters, policemen, judges, psychiatrists are stymied by Billy's rebellion—his innate resistance to the cure of common sense. Decorum. Respectability. Rationality. By the time Billy finally realizes he's looking for the wrong track, their world—the rational, organized, systematized world of the establishment—has lost the match. Now, they have a criminal on their hands. Or an artist.

Ballad of Billy Ockham

Billy Ockham was as sharp as a razor as a kid,
he grew up down in Biddeford, Maine;
and his mama complained from the day he was born,
"the boy's wilder than a runaway train."
Wild all right and full of bloody murder,
his mama always riding his back —
saying, "Boy throttle down before you're run out of town,
'cause you're heading down the wrong track."

It started back in grammar school smoking on the bus,
Billy had to be the tough of the class;
throwing kids down the stairs, pulling Sally Miller's hair,
telling teachers off with plenty of sass —
fifth grade, sixth grade, seven, eight, pass,
nobody wanted Billy staying back;
but they knew they had a problem when he noogied Johnny
 Ahlgren
on the noggin, and he laid that boy flat.

So all these authorities they had this conference
concerning Billy down in classroom five.
His mama was there, the principal was there,
and three teachers with five black eyes.
The principal's conclusion only took about an hour,
an hour and a half, matter of fact —
"The boy's too advanced, he's just too big for his pants,
I think he's headed down the wrong track."

Refrain:

There goes Billy down the wrong track, there goes Billy down the
 wrong track,
there goes Billy down the wrong track and he ain't coming back
 no more.

~

They sentenced Billy up to high school, just what he was needing,
four years with no parole;
and they put him in the shop to burn off a little steam,
down in the gym to keep him under control—
well, it wasn't four days before Billy sawed his civics book
in half with the Black and Decker saw,
and down in the gym he climbed up on the rim
of both baskets and he ripped them right off.

So they crammed Billy up in the college cram course,
'course Billy couldn't write nor read;
but they brought in Milly to tutor on her bank of computers,
and Milly had her M. Ed.
She was working him daily, she was driving him crazy
with those pretty legs and espadrilles—
til one day Billy confused her when he tried to amuse her
And he chased her 'round the terminals.

So all these authorities, they had this conference
concerning Billy down in homeroom thirty-five;
his mama was there, the principal was there,
and sweet Milly with her software smile.
The principal's conclusion only took about a minute,
a minute and a half to be exact—
"The boy needs a probe up in the old cerebral lobe,
'cause he's heading down the wrong track."

Refrain:

There goes Billy down the wrong track, there goes Billy down the
 wrong track,
there goes Billy down the wrong track and he ain't coming back
 no more.

~

Well, his mama finally got him into P. Ivy Prep
by threatening to take the dean's life;
and they put him into botany, locked him in the lab,
hoping he would stay out of sight.
But Billy knew enough not to fool around with plants,
unless they was the kind that you light;
and one Sunday after church when the dean was doing research,
Billy decided to research his wife.

The dean was half way down to the library don't you see,
when he reached in his pocket for his pipe;
not the one with the cob, not the one with the curl,
but the cherry with the academic bite.
But his pocket was flat, he turned around to go back
to his study where he left it on the desk—
walking in he gave a holler when he saw his plant scholar
planting kisses on his pretty wife's neck.

So all these authorities, they had this conference
down in the security wing,
his mama was there, the dean was there,
but the dean's wife was nowhere to be seen.
The decision this time was a foregone conclusion,
that is, short of breaking Billy's back—
it was to pack up his beer and his plants and gear
and have security dump him off at the track.

For the first time in his life Billy found himself free
in that big bad world—the outside;
having been the class joker, he found it kind of hard to focus,
put a foot down, take a step, catch a ride.
No baskets, books, balls, no teachers, study halls,
there was no nothing that Billy could understand—
so smarting like a loser, he threw a rock at a police cruiser
and he got himself right back into a jam.

The cops took him down town and they put him in stir
and the next morning they brought him up to the judge;
and the judge being wise, sympathetic and profound, said
"Son, tell me, what's this all about?"
Billy walked up to the bench with his shoulders kind of hunched
and said "Judge, I've got to confess—
I noogied Johnny Ahlgren on the noggin, it's true,
and Miss Milly? She drove me crazy, I guess."

So all these authorities, they had this conference
and they brought in a Ph D;
not one of those crazy egotists, but a real therapist,
a shrink of the very highest degree.
Nine A.M. Billy was down on the couch,
five P.M. he was cracked—
the shrink put down his note list, he gave this diagnosis,
he said "Son, you're on the wrong track."

Refrain:

There goes Billy down the wrong track, there goes Billy down the
 wrong track,
there goes Billy down the wrong track and he ain't coming back
 no more.

 ~

If you're looking for a moral in this story at all
I'm afraid there ain't very much there;
and you'd be wasting your time if you were looking to find
any meaning—but you know what I hear?
Someone saw Billy down in the freight yard last night,
talking to a hobo in black,
saying "Ockham's the name, and I'm from Biddeford, Maine,
and I'm looking for the wrong track."

"…showed the way to where the fish leaped from the water…"

CHOCORUA

Around the time we took the twins to visit Walden, I was reading to them out of an old children's book on legends of the New England Indians. Their favorite—or perhaps mine—was that of Chocorua, the proud Pequaket chief who refused to leave his hunting grounds for the safer northern woods as the white man advanced. The Pequakets were one of the two major branches of the Sokokis Indians that farmed and fished the Saco River Basin from the New Hampshire mountains all the way to the River's mouth at Saco, Maine.

Like many of the indigenous peoples in Colonial New England, the Pequakets were decimated by European diseases; Chocorua's mate perished in one of the epidemics. Left with a young son, Chocorua remained behind in what is now the Tamworth area as the rest of his people headed north toward Canada. The son grew sturdy and wise in the ways of the woods and mountains. Befriended by the Campbells, a white family homesteading in the region, the boy was accidently poisoned by porridge Mrs. Campbell left out to rid their shack of rodents. Chocorua took it to be murder, and with the husband away in the fields, killed the rest of the Campbell family. He was tracked by a posse to the mountain that now bears his name. Trapped on a ledge, he was ordered to jump or be shot. Chocorua would not be cowed. Legend has it that no green has ever grown on the spot where Chocorua hit the ground.

Chocorua

Chocorua was the sachem, last Abnaki chief to make war in New
 Hampshire;
his Pequakets disbanded, he stands high above the place Swift
 River branches—
white man cut the forest down and settled his domain,
with the flashing of the steel axe blades, the big trees called his
 name:
Chocorua….Chocorua.

Like the Pequots gone before him, he befriended the beleaguered
 English farmer,
shared the milk-white summer corn and showed the way to where
 the fish leaped from the water;
the English traded trinkets for his precious seeds and furs,
and the French made war against the one who welcomed for-
 eigners—
Chocorua….Chocorua.

In the moon before the frozen rains of winter came his wife died
 of a fever;
and the Shaman made the wigwam dance and shake and told
 Chocorua they must leave her!
White man had the sickness and the white man had the gun,
and the Pequakets picked up and left Chocorua and his son—
Chocorua….Chocorua.

Chocorua's son grew strong and learned the ways of woods and
 waters of great Manitou;
and he made friends with the Campbells who were cabined by the
 silver lake Chocorua knew—
one day the boy was visiting Tom Campbell and his bride,
Chocorua came to fetch him home but he found the boy had died!
Chocorua…. Chocorua.

Well the night was wet and wooly when back from the fields Tom
 Campbell found the slaughter;
his family scalped, his cabin burned, his brain exploding with the
 name "Chocorua!"
They found him on a mountain ledge locked in a trance of stone,
and they challenged him to leap and pay the debt the sachem
 owed—
Chocorua…. Chocorua.

Chocorua stepped out to the edge, his eyes wide to the bloody sky
 of morning;
"No white man tell me Chocorua how to die," he cried, and began
 dancing!
Muskets raked the dawn, the last Pequaket shot down,
all green life's withered from the spot Chocorua hit the ground—
Chocorua….Chocorua.

Chocorua was the sachem, last Abnaki chief to make war in New
 Hampshire;
his Pequakets disbanded, he stands high above the place Swift
 River branches—
white man cut the forest down and settled his domain,
with the flashing of the steel axe blades, the big trees called his
 name:
Chocorua….Chocorua….Chocorua.

"Me and Steve had all we could handle with the animals, crops and farm…"

THE BALLAD OF JESSE BOORN

I came across this story in Peter Brooks' *Troubling Confessions*. The Center on Wrongful Convictions at Northwestern University Law adds some colorful detail relying on Leonard Sargeant's *The Trial, Confessions and Conviction of Jesse and Stephen Boorn*. Sargeant was junior trial counsel for the Boorns. His recollection of events in 1873 appears to credit some creative hearsay, especially regarding Colvin's return. Here's the plot: Russell Colvin was related by marriage to the Boorn brothers. You could say his relationship with those boys was not based on familial affection. Colvin's sudden disappearance raised suspicions that the Boorns might have assisted in making him absent. Seven years transpired before a frustrated Town Grand Juror brought murder charges against the brothers despite the lack of a body. A jailhouse snitch named Silas Merrill pointed the finger at Stephen as the killer and Jesse as an accomplice. This in turn for a deal on his own forgery charges. There is some confusion as to why the Boorn brothers confessed. Brooks implies it was out of some dark need to expiate a general sense of guilt; the Wrongful Convictions Center says it was to save their skins. However, there is no confusion with respect to what happened to them: tried, convicted, and sentenced to hang. Shortly before execution day, Colvin pulled into town. So much for jailhouse confessions.

As with the Louis Wagner story, I've painted a bit on the original canvas, collapsed the time frame, and brushed in a few motivations and conversations that the parties alone would have been privy to. I also have both brothers confess only after conviction, primarily out of concern for their souls' future. But the essence of the story remains intact: two men wrongly charged and convicted; two men who confessed to a crime they did not commit; two men saved by the bell—if you can call it saved. Of course, nothing like this could happen today, given our protections under the Bill of Rights, due process, and all that.

The Ballad of Jesse Boorn

The dawn that day was a dirty dawn
was all haze and smoke and ash,
me and Steve got our breakfast trays
hot biscuit, fried eggs and hash —
it's all we asked for, all we got,
what they give you in the gallows trade,
hang an innocent man with a hunk of rope
let the guilty man slip away.

~

Jesse Boorn's my name, brother is Steve,
we ran a sheep farm up in Vermont;
rode into Manchester August fifteenth,
just to see what the banker wants —
Steve, he was up for selling out quick,
me, I couldn't watch her fail —
neither one of us ever got to get our way
'cause the sheriff hauled us off to jail.

August 15, 1819,
got it calendared in my brain,
seems Russell Colvin up and disappeared
and they was thinking me and Steve was to blame —
everybody knew about the feud we had
with him pulling out stakes and pins,
bordering farms with Russell Colvin
made me like to want to kill that man.

Me and Steve had all we could handle
with the animals, crops and farm,
had a mowing rig always breaking down
had a sag in the middle of the barn —
cut our own hay, ate our own corn,
kept the herd this side of disgrace —
but Colvin would let his animals roam
like he owned the whole damn place.

Colvin , he was an angry man,
something eating at him up in his head,
some say it goes way back to the time
that his daddy hung himself in the shed —
can't say it's true, can't say it's false,
who can say what's another man's business?
But I never knew a farmer that hated his farm
like Colvin he hated his.

Refrain: The dawn that day was a dirty dawn...

~

'Bout the end of June the south fence got smashed,
Steve went out to mend the break;
you could tell it was a wheel from the split in the rails,
and the ruts running every which way —
when he got back and he told me that,
I told him what I saw in town:
Colvin's wagon at the livery shop
with a broken wheel laid on the ground.

Word got around we was pretty upset,
there was talk that we made him a threat;
but the only kind of talk me and Steve ever talked
to Colvin went something like this:
"Come across that line just one more time
be the last time you cross a fence."
That was July the fourth at the fireworks show
and we never seen Colvin since.

John Perrault 37

I was thrown in a cell with a Silas Merrill,
Steve was thrown into isolation;
thought they'd break us, keeping us apart,
least that was my suspicion —
Merrill was a forger, talked to his lawyer,
said he got me to confess,
promised testifying to all that lying
and his lawyer got him off I guess.

Me and Steve we sat around in jail
with the leaves turning red on the vine,
bank took the sheep and we lost the corn,
came to trial during harvest time —
judge told the jury they didn't have to worry
no dead body ever turned up —
when the jury heard that they found the fact
that we must have cut Colvin up.

Refrain: The dawn that day was a dirty dawn...

~

Jury voted guilty on the very first round
and the judge sentenced us to hang,
was the end of November, snow in the air,
and the plan was to kill us in spring —
all that winter, here come the ministers,
preaching their Almighty God,
begging us confess and hope for the best
from the power of the Risen Lord.

Well, Steve went first, he broke right down,
said his conscience was ripping him apart;
said he never thought he'd ever come to kill a man,
said the devil got a hold of his heart—
when I heard that, well, my mind went slack,
my thinking went all to sludge—
I dropped to my knees crying "Mercy Lord,
I'm up to my ears in blood."

April 1st they was to come for us,
they had a platform built in the square;
all through March me and Steve at the bars
listening to them hammering the nails—
night before dying, both of us trying
to see our way in the dark—
Steve mumbled something 'bout Jesus Christ
hanging on a wooden cross.

Last day to live, last day on Earth,
sheriff racing into the yard;
he's all excited, yelling for the warden,
yelling to a couple of the guards—
here comes a crowd hot for having a hanging,
come to see us kick and strut—
Steve drops his tray, screaming: "Jesse! Jesse!
there's a dead man coming for us."

Russell Colvin! It was dead man Colvin!
Waving a stage coach stub;
crowd wants a hanging but right there standing
is the man we had killed and cut up!
"I been in New York—if it's anybody's business—
and it ain't—bunch of farmers—I swear…
and you can let those two fools out of your jail
and let them go to hell for all I care!"

All that spring with the flowering
we wandered the fields and the farm,
sprawled out under the maples and oaks,
sprawled in the door of the barn —
now every night on the porch with a jug for support,
Steve breaks into a sweat —
"I could have killed him Jesse, I swear to God,
you might as well if you're going to confess."

Refrain:

The dawn that day was a dirty dawn
was all haze and smoke and ash,
me and Steve got our breakfast trays,
hot biscuit, fried eggs and hash —
it's all we asked for, all we got,
what they give you in the gallows trade —
hang an innocent man with a hunk of rope
let the guilty man slip away.
Hang an innocent man with a hunk of rope
let the guilty man get away.

~

LUCKY JIM

I was reading the Kingsley Amis novel when writing this song many years back. It had nothing to do with the subject, but I liked the title and never knew "Jim's" real name. He was on the streets of Portland when I visited as a youngster on the way to the dentist. Under duress. I remember this: he was blind, had a hound, and a tin cup for coins. His hands like paws draped over the guitar. His voice sounded like nothing I had ever heard on the Philco console at home. It was rough. The song strange. He was not enunciating properly. I wanted to wait for the finish. But the clock was ticking. We can't be late for appointments. I wonder if Jim had any teeth? We'll all be keeping our appointments by and by.

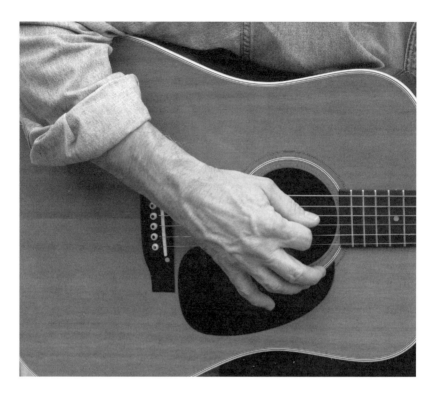

"…fog painted on his glasses with a guitar in his hand—"

Lucky Jim

Down the street around the corner stands this rumpled little man,
fog painted on his glasses with a guitar in his hand—
cup tacked to the shoulder strap, mouth harp at his chin,
just a one man band on a two-way street and they call him Lucky
 Jim.

This old wolfhound stands beside him like a doorman at the Ritz,
gold braid for a collar, you know it makes a dog feel rich—
blue eye for the passersby, black eye for the trail,
and he whines a sharp when he hears the harp till Jim steps on
 his tail.

Refrain:

Lucky Jim—what a sight to see!
He'll yodel you a tune and help you get to where you want to be
 (you know it's true).
Gets you smiling and he picks you up, you can drop in a quarter
 in the old tin cup—
Lucky Jim, he's guaranteed to please.
 ~

He sings the songs about the big rail box cars that the hoboes
 used to climb,
he sings a song about a wreck on the Boston & Maine that he
 walked away from blind—
and he's lost to the rhythm of the clicking rails, just a sad man rid-
 ing a train,
but you should hear him laugh when he hears somebody asking
 him for change.

Now this kid comes up to Lucky Jim, and he says "Hey man, can
 you play Dylan?"
Jim says "Shucks," he tells the dog to hush and he says "Kid—are
 you kidding?
Why I'm the original tambourine man boy, I do all of Bob's
 arranging—
I just got back from Malibu where the times they are a-chang-
 ing!"

Refrain: Lucky Jim—what a sight to see...

~

Jim's a preacher and a politician, all wrapped up in one,
swears on the truth of the Bible, but he lies like a son of a gun—
ask him a serious question, he'll give you a serious grin,
pull your leg till it's right out straight then send you hopping
 down the road again.

Now here's this fancy lady in a limousine, traffic backed up in a
 jam,
she hears Jim bawling out a bluegrass song, she says "Gracious,
 that poor man."
She gets out of the car and walks him over a dollar bill saying
 "Sir, this is to lay away."
Jim taps her on the rear, he says "Thank you dear, but I'm all tied
 up today!"

Refrain: Lucky Jim—what a sight to see...

~

Jim makes a laughing stock out of the brokers, blasphemers out
 of the priests,
housewives out of the college girls, and junkies out of the police—
you know he gets folks laughing at themselves, feeling kind of
 good,
feeling lucky as Lucky Jim would like to if he could.

So if you want a little local color, and you don't mind a little pain,
you want to learn how it is riding the caboose at the end of the
 human train—
take yourself down to that corner where this rumpled little man
sings for pennies for his supper, with a guitar in his hand.

Refrain:

Lucky Jim—what a sight to see!
He'll yodel you a tune and help you get to where you want to be
 (you know it's true).
Gets you smiling and he picks you up, you can drop in a quarter
 in the old tin cup—
Lucky Jim, he's guaranteed to please.

~

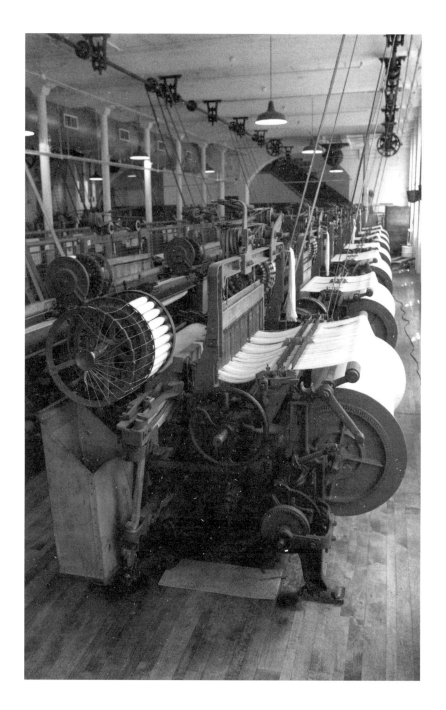

"He wound the bobbins on my machine..."

MANCHESTER HEARTBREAK

I grew up in a French Canadian mill town, smaller but not unlike Manchester. My aunts on my father's side worked in the cotton mill. Imagine an L-shaped room, each section the size of a football field crammed with five hundred or so looms banging away like Howitzers. Yelling into your partner's ear was never loud enough; sign language only. In summer, temperature broaching one hundred degrees, steam pouring in to keep the threads damp, cotton puffs floating through the air—I wouldn't have lasted a day in there. Some of the kids I grew up with were on a one-way track into that mill to work the looms with their parents and cousins. What happened to them when the mill went south?

This young lover's lament tells an oft-repeated tale that's not limited to the mills. It's an old story. The traditional American ballad, "The Railroad Boy," is an earlier, rural version.

Manchester Heartbreak

"In a factory town by the Merrimac River,
Paul Dufond made my heart quiver —
he promised that he'd marry me,
now he's gone away in other company."

Refrain:

Fare you well, my friend my love,
wherever in this world you roam —
but every night when the stars do shine,
it's you, it's you, that's on my mind.

~

"He wound the bobbins on my machine,
he'd walk me home and he'd buy me things —
but the open road passed by my door,
no use, no use, begging him don't go."

Refrain: Fare you well…

~

"Oh mother dear, what can I do?
My Paul Dufond, he's been untrue —
I'll go upstairs, and I'll close that door,
and I'll cry and cry — till I can cry no more."

They called her father home from the mill,
he ran upstairs, just to comfort her —
he knocked three times, then he tried the door,
and he found his daughter lying on the floor.

Well, he picked her up like she was still a child,
her hair hung down, and her eyes were wild—
"Oh daddy dear, look what I've done,
I gave my heart to Paul Dufond."

Refrain:

Fare you well, my friend my love,
wherever in this world you roam—
but every night when the stars do shine,
it's you, it's you, that's on my mind.
It's you, it's you, that's on my mind.

~

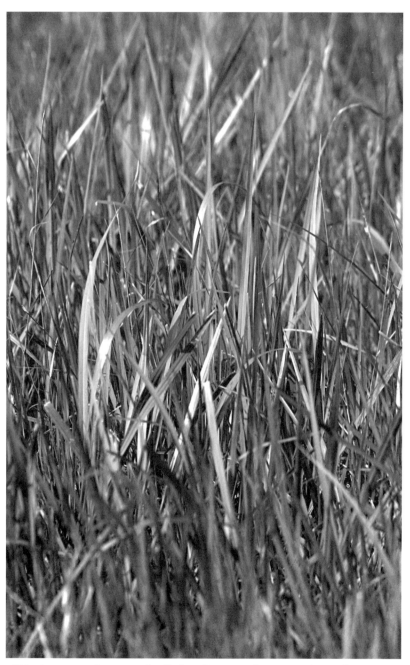

"Corinna see the way the light glints on the tines through every fork of grass"

Mad River Road

First person narrative tends to disqualify a story song from the ballad category. I won't be so fussy about it. The speaker here is a character—as much of one as is the beloved Corinna to whom he pitches his tune. I love her name—akin to Kore of the corn. Or Demeter (Ceres), her mother. Evoking images associated with the fertility myth, Corinna could be a corn goddess in her own right. I can't recall the catalyst for this piece. It feels today like I must have been in some kind of dream state when composing—despite all the warnings by my betters growing up: don't dream away your life.

Mad River Road

Running old down mad river road that turns back into time
I chanced to find a country couple making hay,
I looked upon the cutting one who seemed to be of mind
to say I'm sorry that your life turned out this way —

Corinna see the way the light glints on the tines through every
　　fork of grass
I toss and turn to sweeten in the sun,
Corinna smiles the blush of summer swelling apples in the
　　orchard
as she turns to him blue eyes lit up with love.

Well I slowed my pace when I saw her face and I heard the
　　mower's song
it was so long ago that I was haying too,
the smell of grass the maiden's laugh the highway just beyond the
　　field
they worked as if to offer something new —

Corinna see the way the highway snakes its back out of the coun-
　　tryside
to twist and turn and angle toward the town,
Corinna gazes from the meadow turning slowly on her shadow
and her lips begin to move but there's no sound.

I stopped to rest by the meadow's edge and I thought about my
　　life
the sickle sighing in the long grass summer grew,
the mower coming closer and the maid right by his side
I realized that they were people that I knew —

Corinna see the way I'm feeling with this mowing every season
something's over something's lost I can't describe,
Corinna pauses as a wisp of wind comes dancing through the
 grasses
reaches up to sprinkle dust into her eyes.

The flashing blade the sighing maid we play the parts we choose
two lovers lying in a meadow after noon,
mowing done one starts to run the other doesn't move at all
Corinna I've come back—Corinna—

Corinna see the way the light glints on the tines through every
 fork of grass
I toss and turn to sweeten in the sun,
Corinna smiles the blush of summer swelling apples in the
 orchard
as she turns to him blue eyes lit up with love.

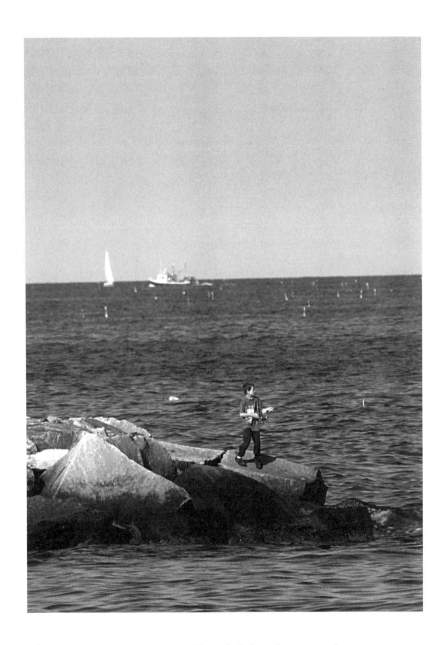

"When I was a young man I angled for pleasure…"

SONGS

Before You Go

The stone wall stands beside the road,
divides the land, upholds the code—
but here's a gap to make it through,
come take my hand, it's getting cold.

The sifting snow falls on the spruce,
on ash and oak, and darkness due—
there's not another soul in sight
to see us here, it's just me and you.

The winter trees all black and white,
the buried leaves, the silent night—
but there's an engine humming low
back up the hill, just out of sight.

The woods are deepening in snow,
the lake is freezing down below—
come a little way before you go,
just a little way, before you go.

The woods are deepening in snow,
the lake is freezing down below—
take a little time before you go,
just a little time, before you go.

Saco River Song

There's a place where this river runs slowly and deep,
there's a place where this river stands still;
where the banks spread apart like a young woman's heart
when her young man comes over the hill—
it's a place you can go if you know the back roads,
past the skid shed just down from the dam;
you put in at the bridge below Pequaket Ledge
and your stretch of wild water begins.

You crash through the water and you cut through the waves,
and you slide past the rocks in the bend;
dodge that sunken old birch that some beaver has worked,
duck the willow and that dying old elm—
then you're down on the bars, you sleep out under the stars,
and you lay out all day in the sun;
and you let your pain go as this sweet water flows
like two lovers when their loving is done.

And there's no one to miss you, no one to call out your name,
and no one to say you're forgiven;
there's just the leaves on the trees, they've got something they
	want to tease you 'bout
but you don't have to listen, to listen—
and the breeze flutters warm on the afternoon calm
and the sky just keeps floating away;
you're no longer there, you know you just disappear
like a shadow at the end of the day.

I left New Hampshire in the flood of the year,
and I pointed my Old Town to Maine;
and the river was high, you know it ran like the tide,
it was the season of rain after rain—

John Perrault 57

somewhere out in the fog of that old Brownfield bog
I heard the screech of an owl,
and it followed my canoe all the way to the Pool,
and it's still with me, still with me, now.

WHITE-TAILED DEER

Can't you love me tonight, in this moon-lazy light?
Put away all your troubles, let a little love through.
Can't you put down your pride, who was wrong? Who was right?
If you're needing an answer, then let it be you.

Time is the star shine, light years away—
tomorrow can't undo what we do today.
That night we saw the white-tailed deer,
up on the ridge behind the mill—
I told you then I'd always love you,
and I will.

Look up through the trees, with the moon on the leaves,
let peace in, let's sweeten this night—don't refuse.
It's not so hard to decide, who was wrong, who was right—
if not me for some reason, then let it be you.

Time is the star shine, light years away—
tomorrow can't undo what we do today.
That night we saw the white-tailed deer,
up on the ridge behind the mill—
I told you then I'd always love you,
and I will.

MOUTH OF THE RIVER

When I was a young man I angled for pleasure,
measured my luck by the tug on the line;
now I'm an old man at the mouth of the river,
ever going to be a new man it will be in your eyes.

Go out on the water, you're expecting some fishing,
fishing is something that the ocean decides;
cast out your line, oh you study conditions,
fishing ever going to be right it depends on the tide.

Stars in the eelgrass—they make fishing easy,
moon's got a mind to please the point of your pole;
know where we're going? Out on the edge of the jetty.
Ever going to have a good night, it's there goodness knows.

When I was a young man I angled for pleasure,
measured my luck by the tug on the line;
now I'm an old man at the mouth of the river,
ever going to be a new man it will be in your eyes.

SOME THINGS REFUSE TO FALL

Leaf on a sapless limb of an oak,
stone upon stone of a wall—
blood up the trail of some buck-trampled grass,
some things refuse to fall.
Some things refuse to fall.

A man and woman searching in the middle of the wood,
in the winter wood, whatever the cost—
deeper in the middle of the darkest part,
some things refuse to get lost.
Some things refuse to get lost.

Rush of the river in the flood of the spring
making everything tremble and quake—
supple little sapling of a birch sprung back,
some things refuse to break.
Some things refuse to break.

Old man in the mountain, older than we thought,
there's a hole in the notch on the wall—
climber on the rock face holding back the tears,
some things refuse to fall.
Some things refuse to fall.

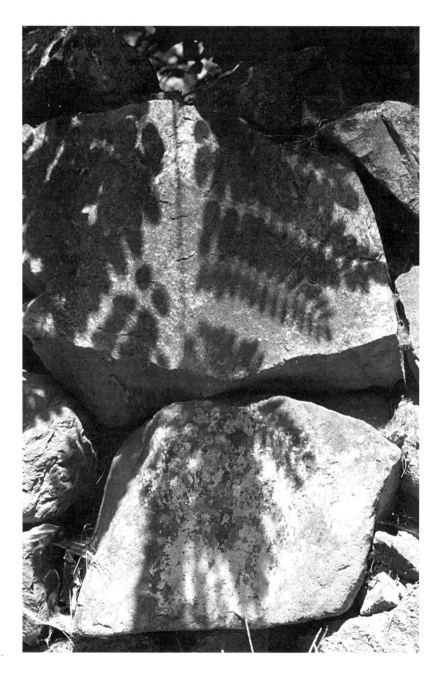

"…that feeds the trees
　　that shade the stones."

POEMS

INDIAN SUMMER EVE

She turns to him
in the pale light

opens the book to the place
she left off last night
folding back the cover

and reads to him
there on the long white porch
with the warm wind
from the satisfied fields
lifting her hair

with the warm wind
fondling the silver leaves
still in the alders

reads to her soldier—
the exile returned
home from Vietnam
leaning on the rail of his chair
inhaling the line from Lowell:
"…your life is in your hands"

who watches her rise
from the wide pine step

with the moist moon
in her eyes

to hover over him
and hear her say again:

"…your life is in your hands."

NAILS

What once was a farm
now edges the woods
off a Knox County two-lane —
half clapboard,
half paper and strapping.

The back shed's glued
to the sagging barn,
broken window panes —
there's a rusted-out Ford
in the yard, wheels missing.

The front porch is pulling
away from the house,
not much left of the sills —
clothes strung out on a line
under the eaves.

Looks like a lady's blouse,
skirt, some under-things —
and tacked up on the rail
there's this home-made sign:
"Nails by Maggie."

BEANS

Charter's beans are poking through the dirt
right on schedule,
six more weeks and on the plate.

Meanwhile, he'll marinate
them with a squirt
of water, pinch of thumb , occasional

shot of spit: "You don't want to rush
them up the stick
before they get a grip on the ground,"

he likes to say—"a good round
bean's ready to pick
when it's ready. Little nudge but don't push."

THE STONES

The stones stand in walls
along the ridge.

Edges worn by wind
by rain

they remain in place
wedged together

bounded by each other's face
like skulls in catacombs.

The bones that balanced them
to clear the fields
and guard the lines

are meal now
beneath the ground.

Ground by time
to a dark past

that feeds the trees
that shade the stones.

THE TUGS

Up river
three harbor tugs
nose a crippled tanker
majestic with rust
to the terminal dock

they hug close
like calf whales to a stricken cow
not about to let go
not about to let the tide
push them around

a shag sails down
skimming the eel grass
the glistening muck and plastic wrack
to land on a piling

watches as they nudge her in
holding fast
tending the gash in her side

even with her lashed tight
the tugs hang on

even with the job done
bobbing in a slick of oil

now the smaller one
glides slowly out toward open water
spouting smoke

now
the others.

THREE JAYS IN A BLIZZARD

Blue jays don't bear
winter; they wear it out
like an old sheepskin—
ragged, full of holes,
thick enough for cover
when it's cold.

Wrap the snow around
themselves and disappear
up there in the pine
til the wind comes looking—
finds them tucked tight
and throws a fit.

Don't flinch. Don't scratch.
Just watch winter flap
open and freeze. Exposed.
Jay blue naked
birds on a dead branch—
three in a row.

Senior Citizen Outing at Winnipesaukee

The walleyed pike
takes the bait

jigs up gray granite ledge
out of the lake
making a dance of it

slapping the stone
red.

Chasing a thread
of some long green desire
the fish
flips through air
to the end of the line

where little Meg
with the blue hair

never caught a thing
in her life

waits
waving her see-through
black nylon
net.

ANNE HUTCHINSON

She went about her business,
not her husband's,
looking for the light within.

To the clergy: antinomian,
heretic. Let her stand
for trial and address

the charge. The only witness
her risen hand
to swear she no more sinned

than any God-fearing man
in search of truth. And,
there she failed the test.

Who was she to not confess
her folly? To Rhode Island
banished then, for rebellion.

Was later learned the Indians
unlit her. So God planned
said some in Massachusetts.

HOMELESS ON THE COMMON

Withered
weathered from walking
wounded by neglect

pushing along
a grocery wagon load
of everything she owns

she's found a bench
for warming
for talking to her birds.

Somehow she gets them
pecking the ground
around her feet

feeding
on the words she scatters
from frozen lips—

she spits them out
as if too bitter
for the tongue

each one
a seed of some dried flower
from her half-empty bag of memories.

Newfound Lake, Late September

Now the cold
coming in old clothes
over the needled floor
edging the lake,

the aged grounds keeper
coming
to shut the water off
for winter.

Now stopping
at the black line of shore
to catch breath
and think:

do I have everything
I need?
Now bending low
to fiddle with those hard white hands.

May Music in New Hampshire

Listen children,
lean close to the earth—

you can hear the young fiddleheads
tuning up,

practicing under the leaves,
minding their clefs,
waiting for the green curtain to rise.

Look how they let
my long fingered rake
play over them,
oh so lightly,
so as not to break the strings.
So as not to ring their little necks.

See how fresh and eager they appear,
turning to the woodwinds,
focusing the air,

breaking out of root position
to scale the blue light.

THIRTEEN AND SKINNY AS A SPINDLE

Glimmering day
　　bay blinding light,
keep me in sight at sea
　　as I head out—

press on the waves
　　the wind offshore
to hold things down,
　　lay a calm
beyond the spindle,
　　let me row.

Last night's moon
　　caught my heart
fumbling in the dark
　　for the line to hers,
my tongue tied up in knots—
　　let her spy me now
untangled
　　pulling past the buoys.

Turn the glass
　　she's maybe lifted
from the cliffs to me,
　　brown me bronze,
burn my back;
　　track me out to the mark
that makes me shimmer
　　from the shore—
let her see me manning oars—
　　point me out.

FRESHMAN

Dark fell early,
 a freezing rain,
my left foot
 pedaled the clutch—

we sat in the car
 as the lights came
on the poles,
 and didn't touch.

Not even hands.
 We sat there apart,
watching ice
 crust on the glass—

waiting for a stuck
 thermostat
to kick in—
 I ran out of gas.

THE PIANO

A cottage left for winter can be rough—
cold scuffs the floor boards in the hall,
the walls creak and shiver with the wind
and closet doors tend to click, unclick,
as if trying to latch on to something
close at hand, but can't connect.

In the cupboard, thank god, the bottle
didn't freeze, icicles rattle
in my glass; I pass the salted windows
wrapping every room except the den—
dark as ever—yet, in the mirror
on the mantel, my children swim.

The upright in the corner wears a sheet
of white, the angels in the photograph—
wings. I pour another scotch, spread
my fingers out to find the key of C
for "Silent Night" and sing it flat—
no matter—nobody here but me.

ALL SOULS EVE

As the mist lifts from the cut swale
the deer slip out of the trees

dropping their shadows to the meadow floor
baring themselves to the moon —

slowly they turn in the pale light
moving in groups of twos, of threes

testing the earth with their silver hooves
their eyes coming toward us.

About the Author

John Perrault is a practicing attorney in both Maine and New Hampshire. He teaches a course in politics and literature at the University of New Hampshire, and American Literature at Southern New Hampshire University. A published essayist and poet, his work has appeared in *The Christian Science Monitor, Commonweal, Poet Lore, Key West Review, Accent,* and numerous other publications. John has also recorded six albums of original and traditional music, accompanying himself on guitar. He is the current Poet Laureate of Portsmouth, New Hampshire. This is his first book.

For booking readings/concerts or for further information, please contact John at rockweed@comcast.net. You may visit the Portsmouth Poet Laureate Program and read more of John's poems and essays at www.pplp.org.

About the Photographer

A native of the New Hampshire seacoast, Peter E. Randall is the twelfth generation of his family to live in the region. He has been involved with publishing and photography since graduating from the University of New Hampshire as a history major. Before he began his own publishing company, he was editor of a weekly newspaper, and for seven years edited *New Hampshire Profiles* magazine. Since 1974, he has authored 13 books ranging from collections of photographs and travel guides, to local history.

He received the Lifetime Achievement Award from the New Hampshire Writer's and Publisher's Project in 1992, and the Granite State Award for contributions to the state of New Hampshire from the University of New Hampshire in 1993.

Known for his images of New Hampshire and New England, he has also made photographic journeys to five African countries, and to Spain, Portugal, and Guatemala.

About the CD

The Musicians appearing on the enclosed CD are:

John Perrault, guitar & vocal.

Mike Rogers, harmonica; back up vocal on "Sonny's Back" & "Manchester Heartbreak."

Ellie May Shufro, violin on "Sonny's Back," "Chocorua," & "Mad River Road;" back up vocal on "Sonny's Back."

Barbara London, flute on "Ballad of the Squalus" & "White-Tailed Deer."

Jim MacDougall, bass on "Sonny's Back" & "Ballad of the Squalus;" piano and back up vocal on "Ballad of Billy Ockham."

Newt McKay, bass & breva casa on "Chocorua;" breva casa on "Some Things Refuse to Fall."

David Surette, bouzouki on "Before You Go."

Jamie Decato, drums on "Ballad of the Squalus."

Ric Harris, second guitar on "Mad River Road."

Engineer: Jeff Landrock, Landrock Recording Services, Berwick, Maine.

CD design: Tom Daly, Crooked Cove Records, Kittery, Maine.

All ballads and songs are published by Rock Weed Music, ASCAP.